P9-CAH-023

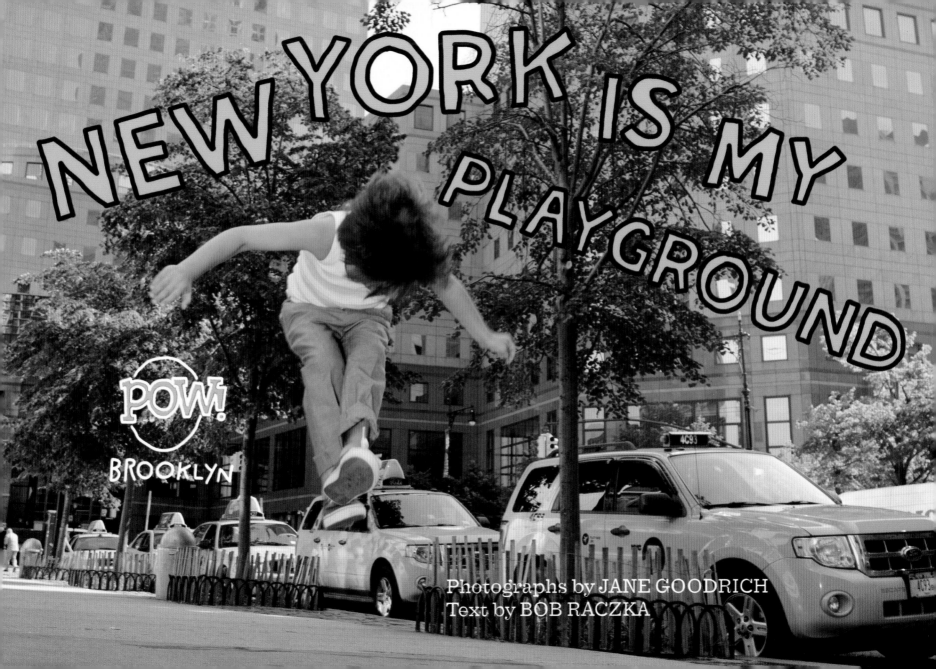

NEW YORK IS MY PLAYGROUND

POW!
BROOKLYN

Photographs by JANE GOODRICH
Text by BOB RACZKA

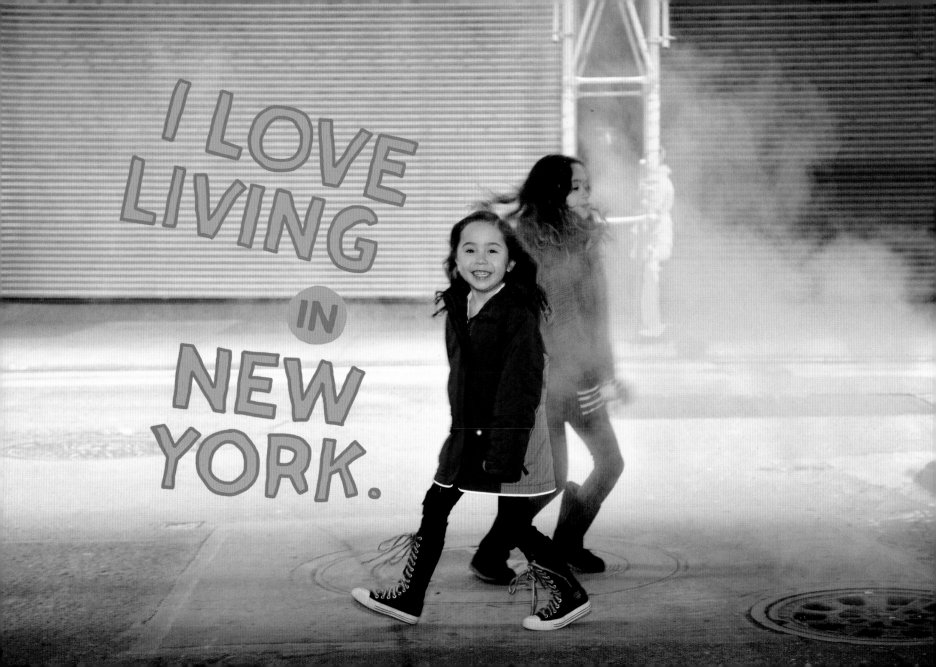

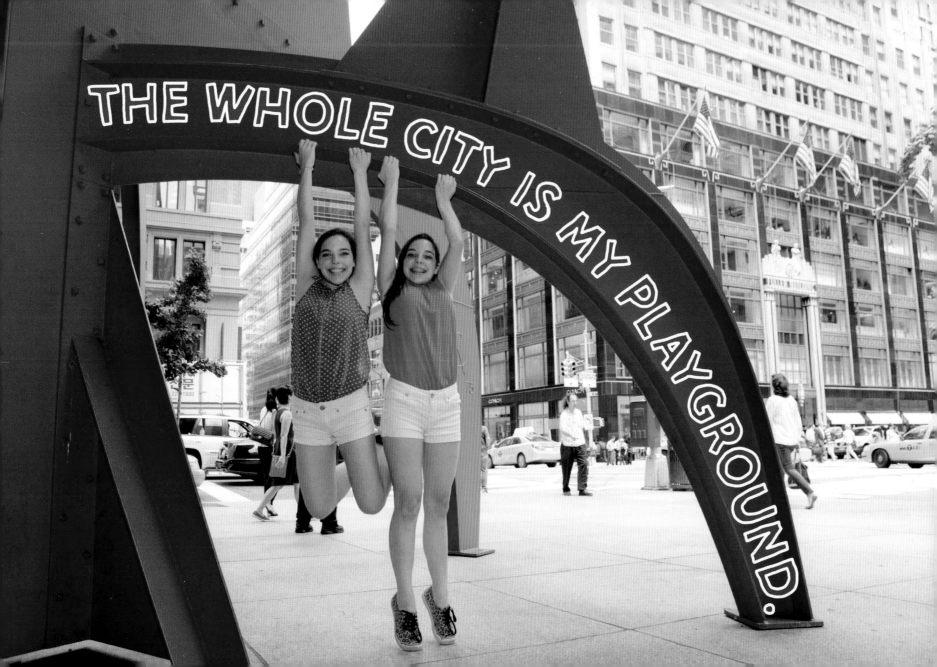

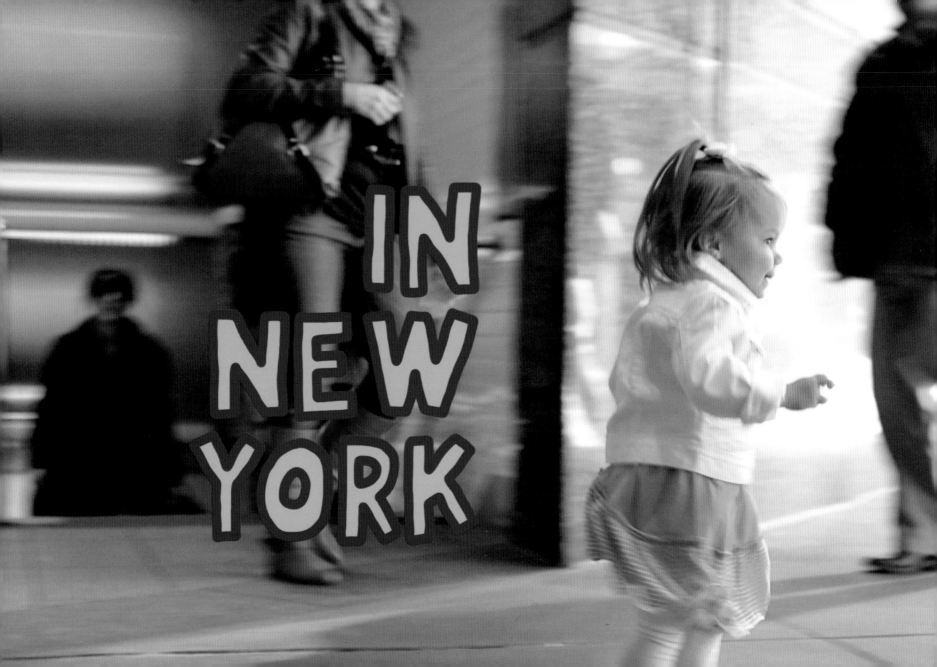

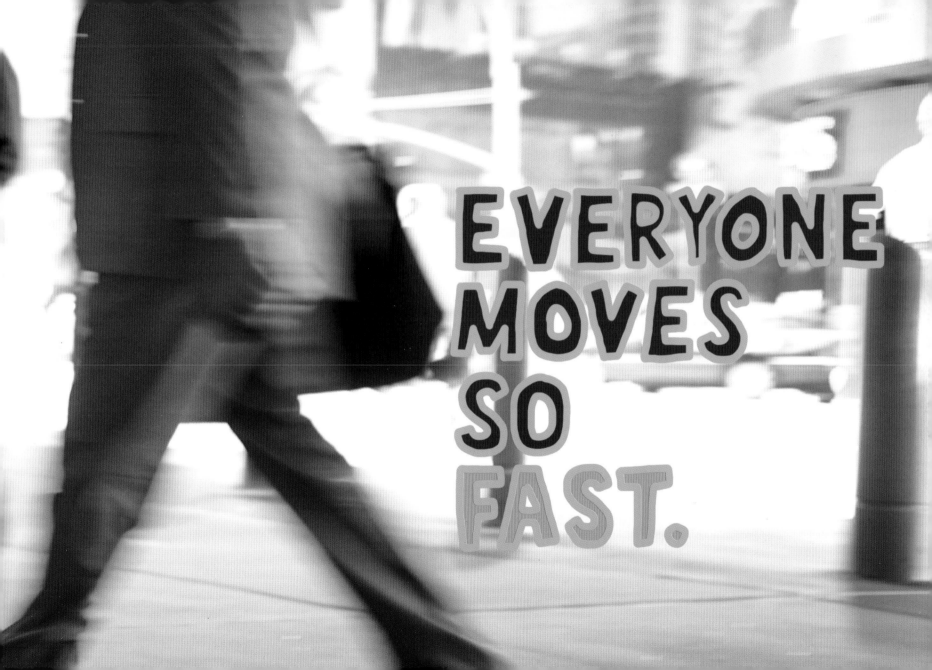

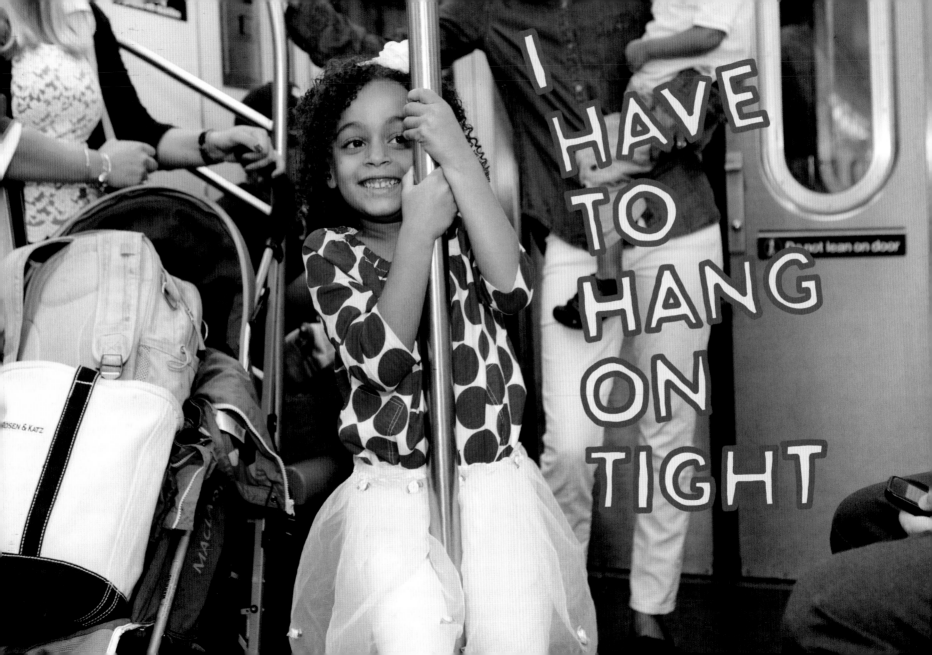

I HAVE TO HANG ON TIGHT

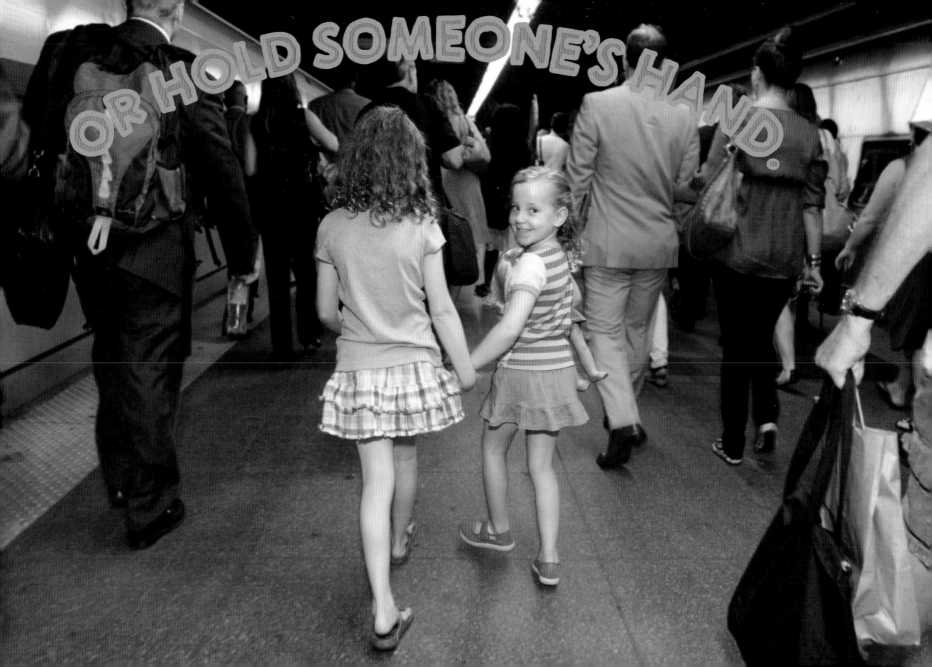

OR HOLD SOMEONE'S HAND.

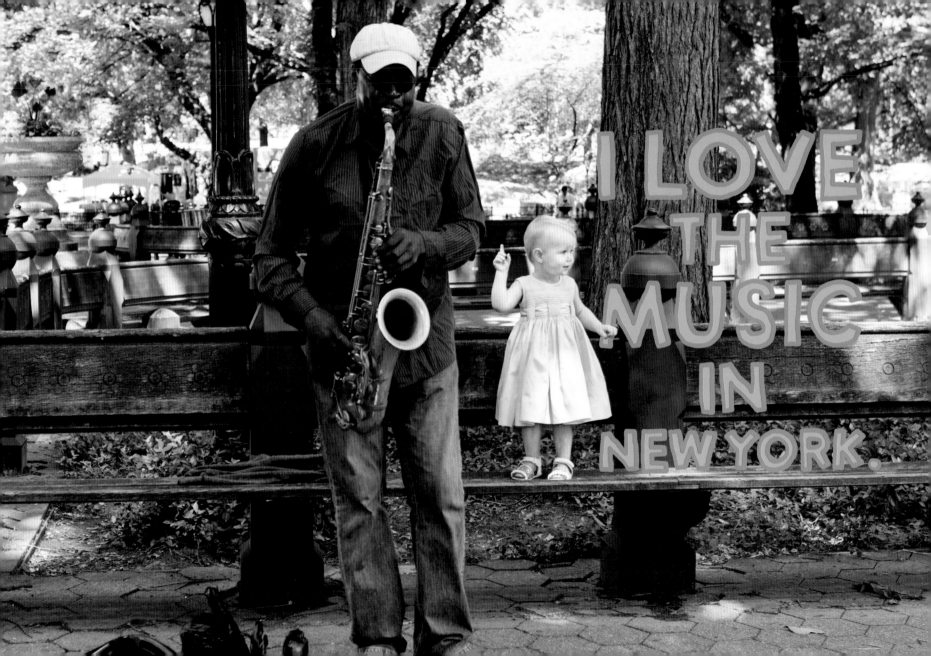

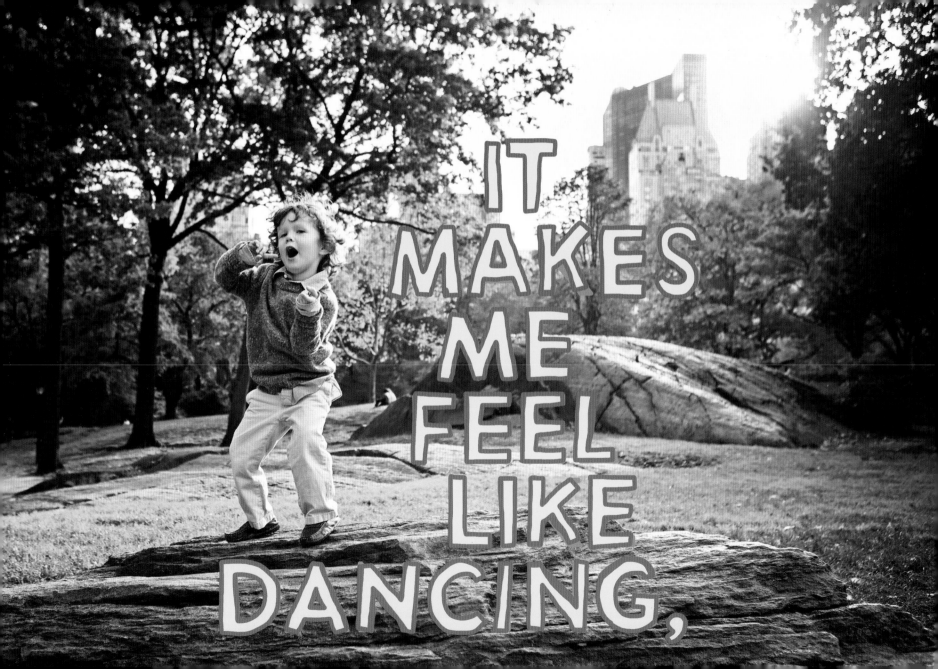

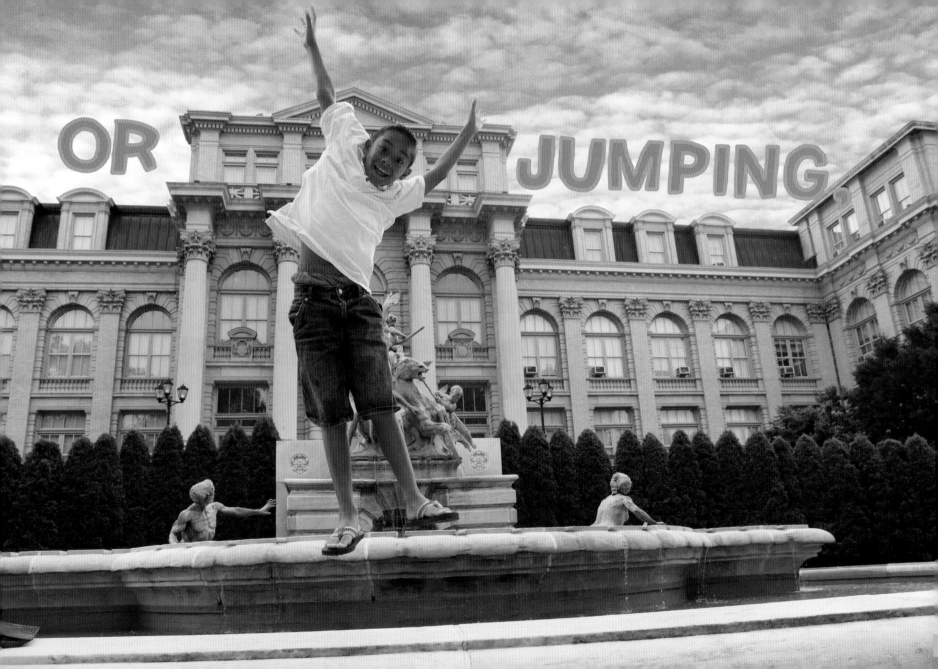

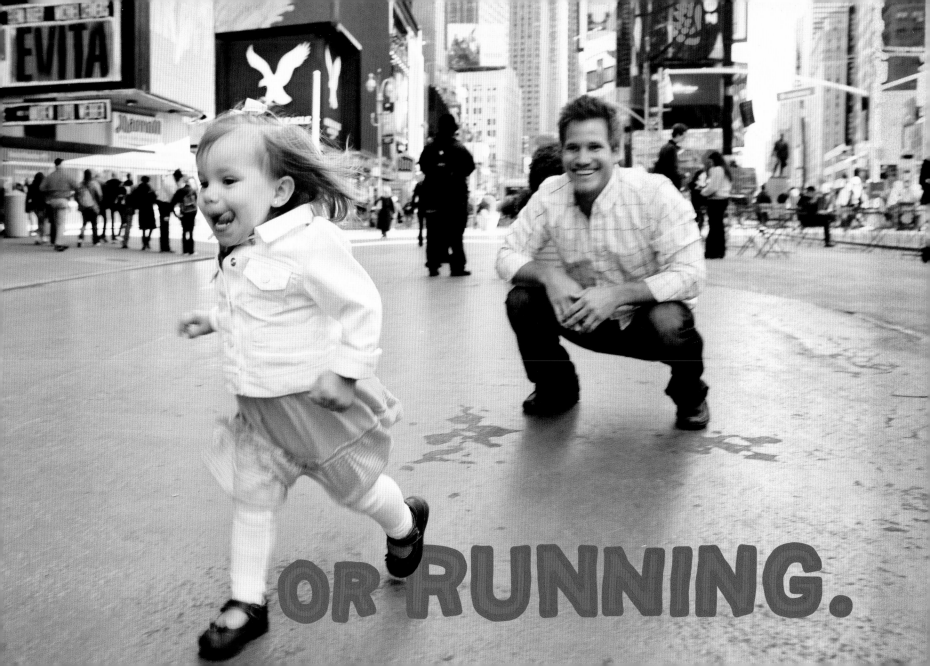

OR RUNNING.

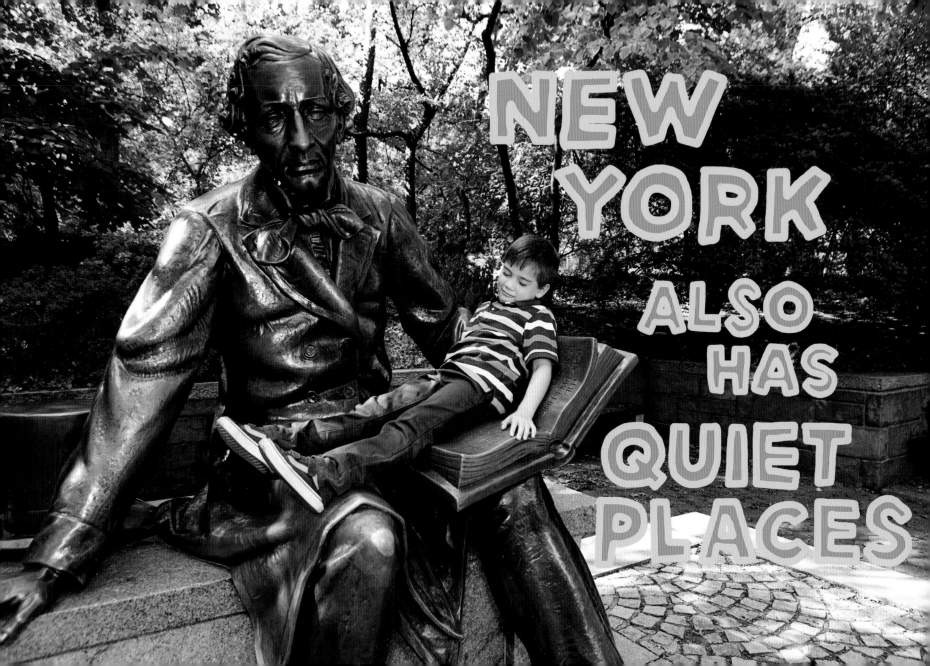

NEW YORK ALSO HAS QUIET PLACES

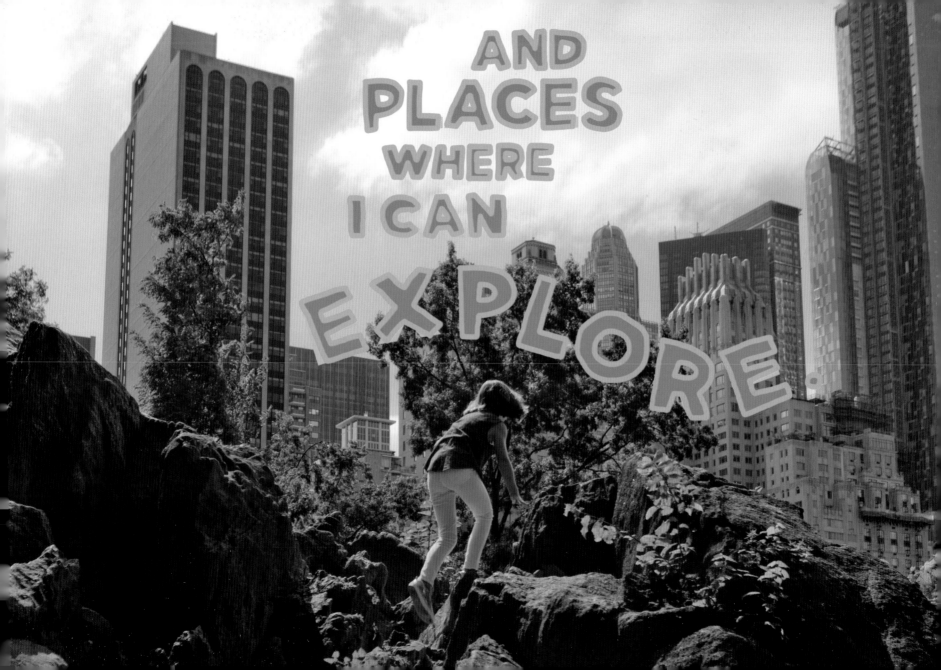

AND PLACES WHERE I CAN EXPLORE.

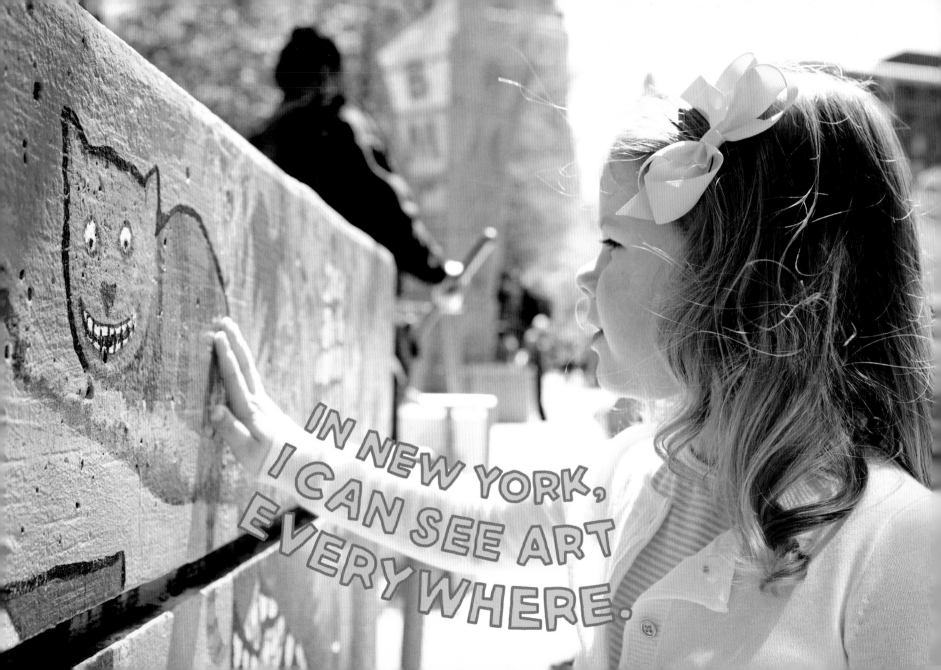

IN NEW YORK,
I CAN SEE ART
EVERYWHERE.

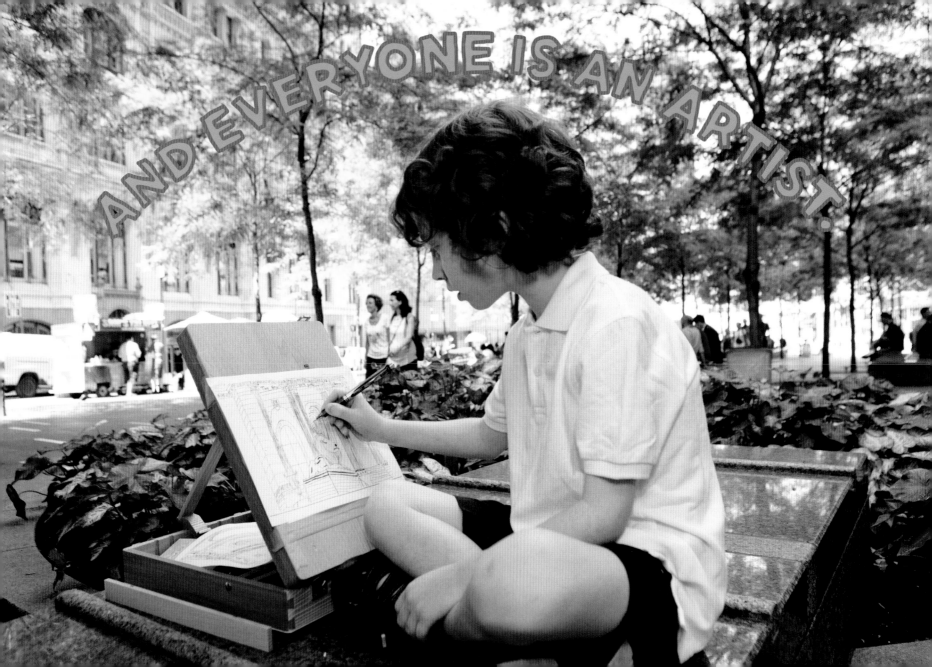

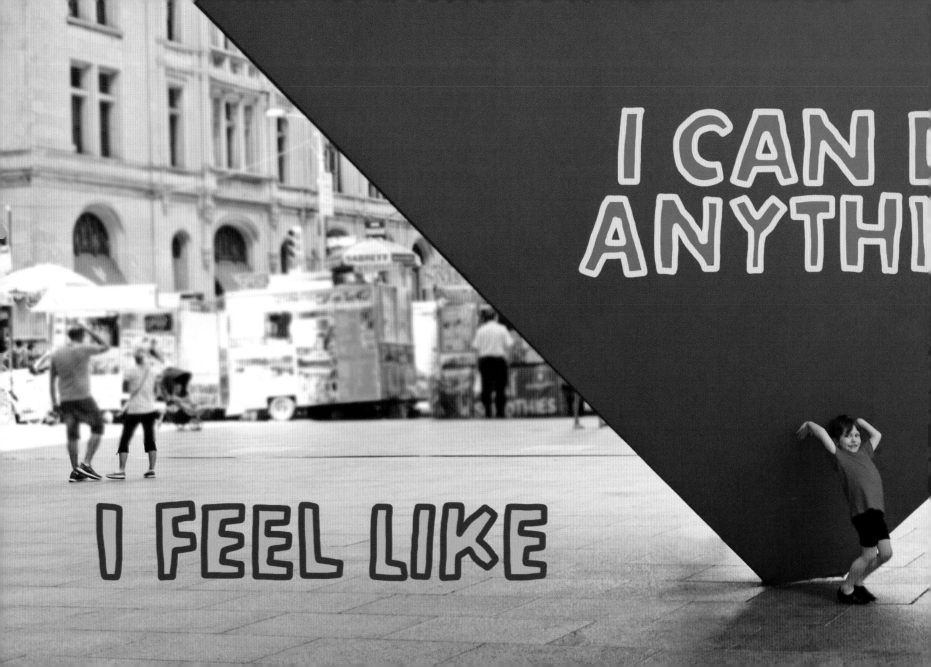

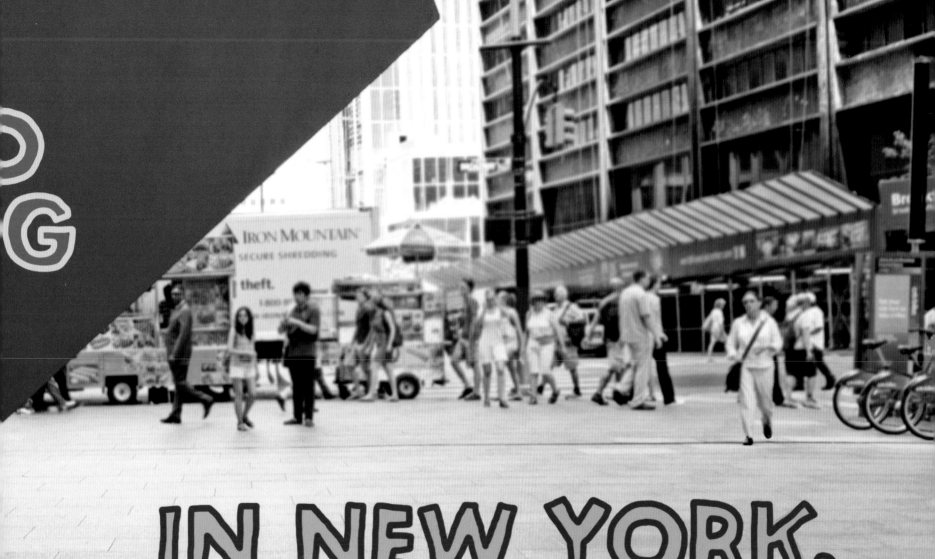

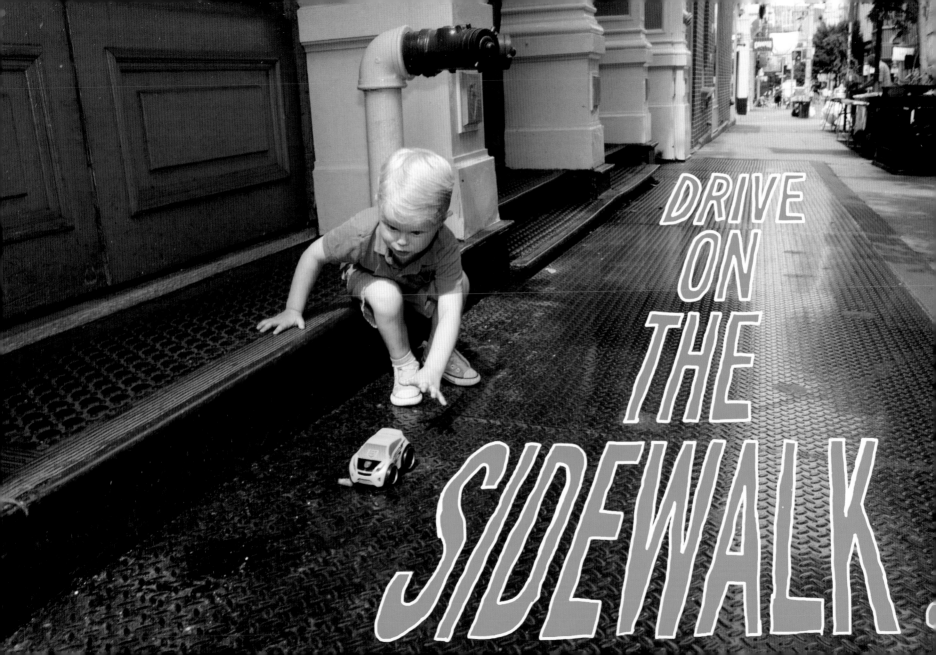

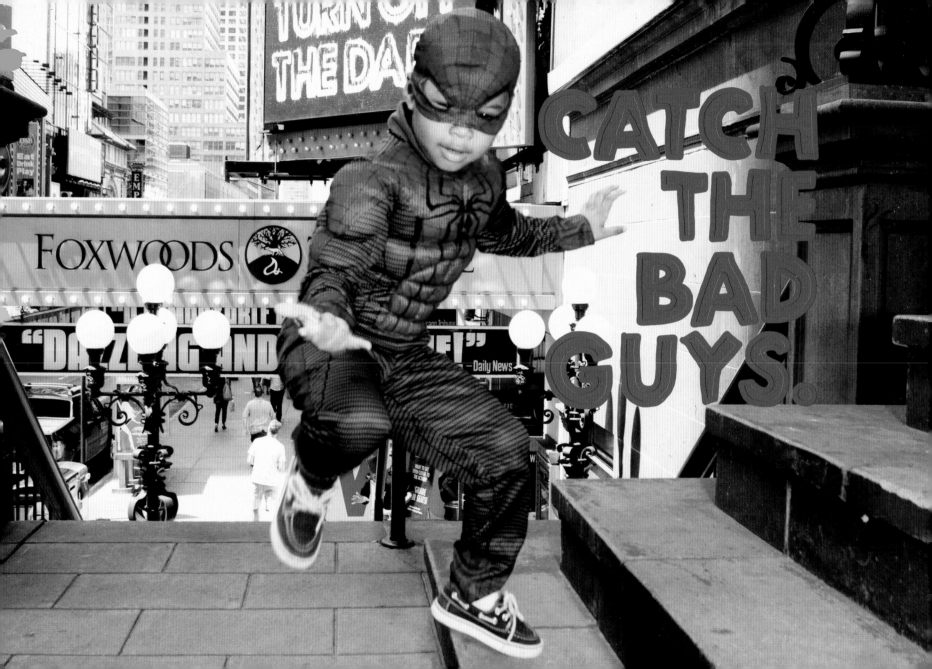

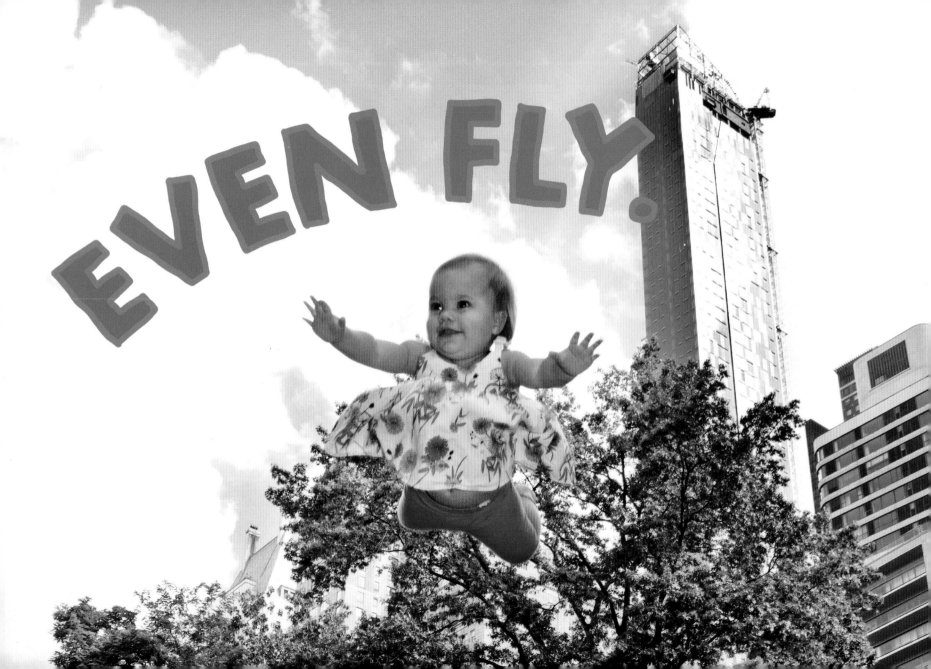

NEW YORK MAKES MY FEET HAPPY.

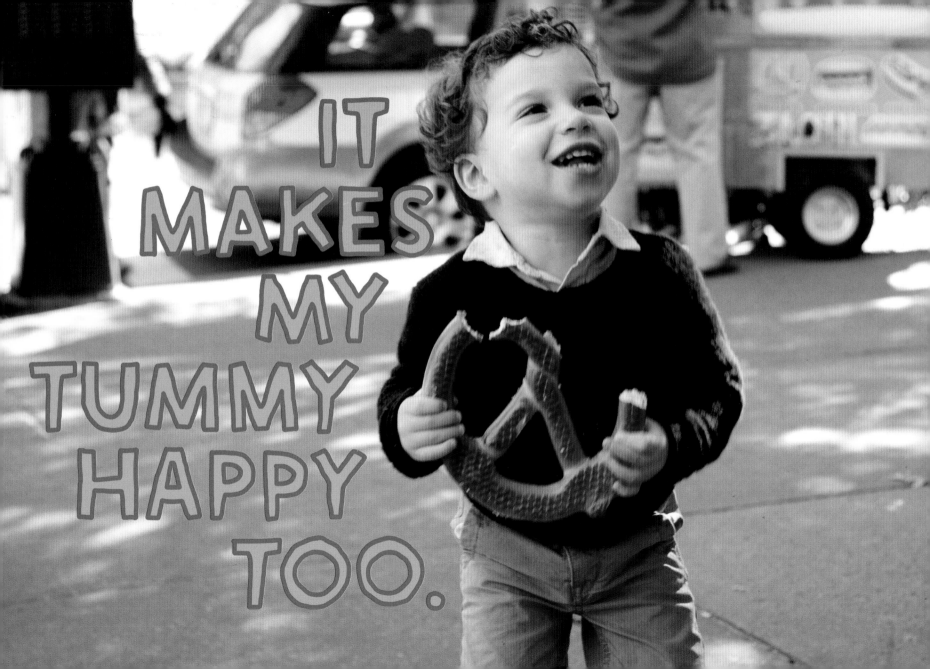

IT MAKES MY TUMMY HAPPY TOO.

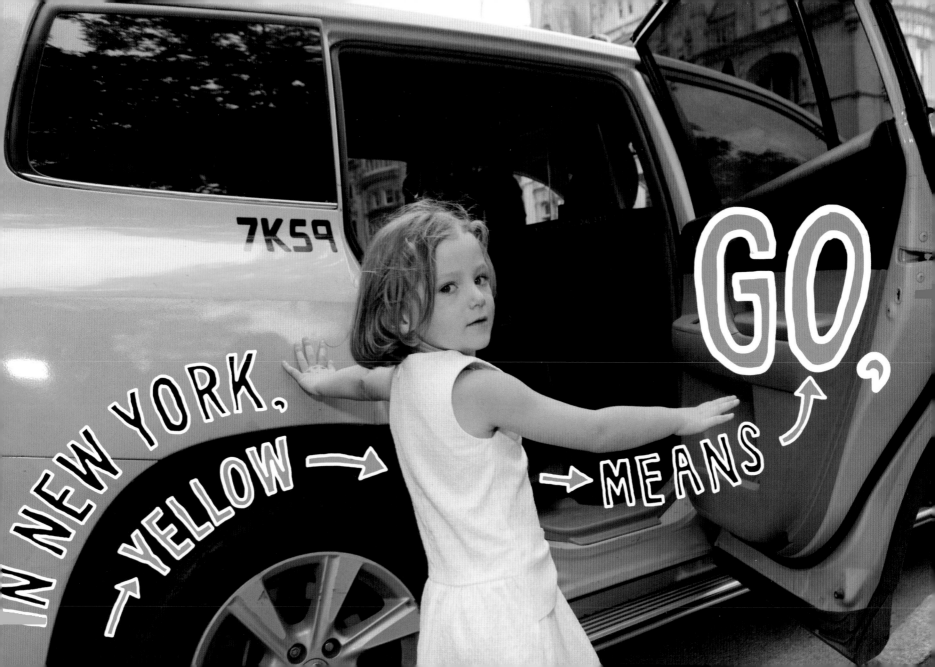

IN NEW YORK, →YELLOW→ →MEANS GO,

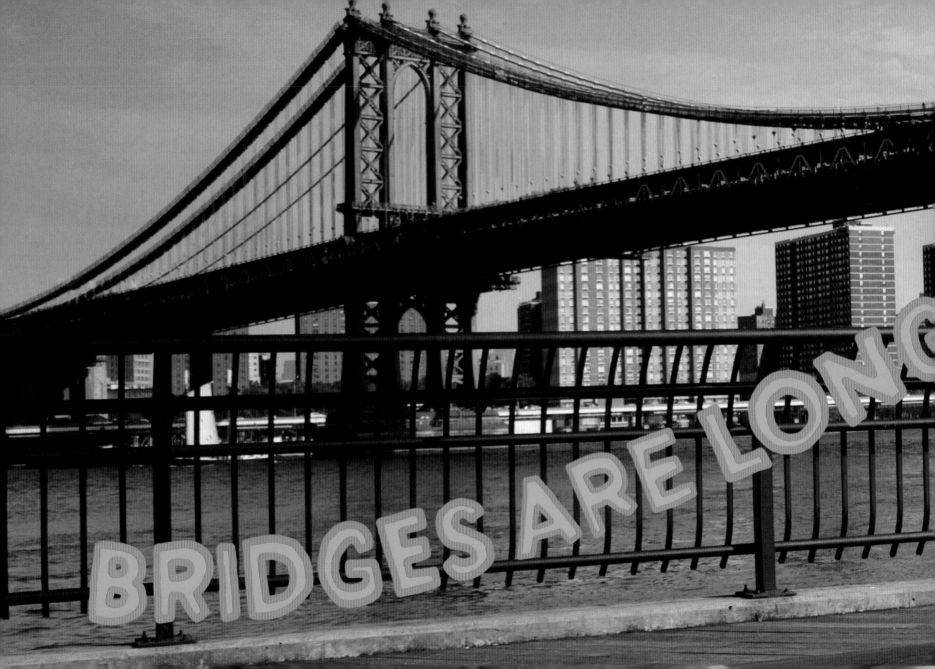

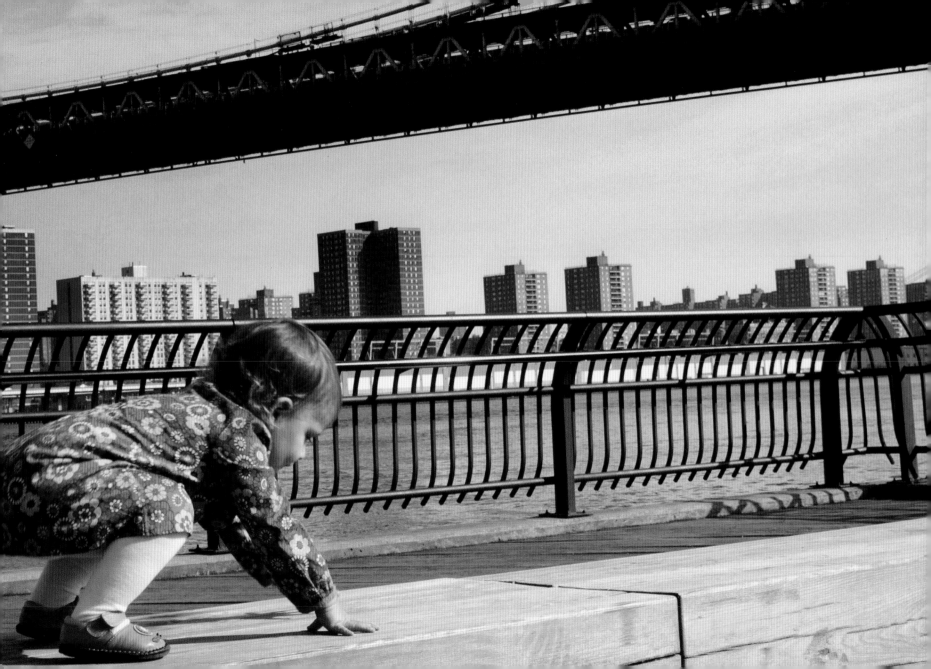

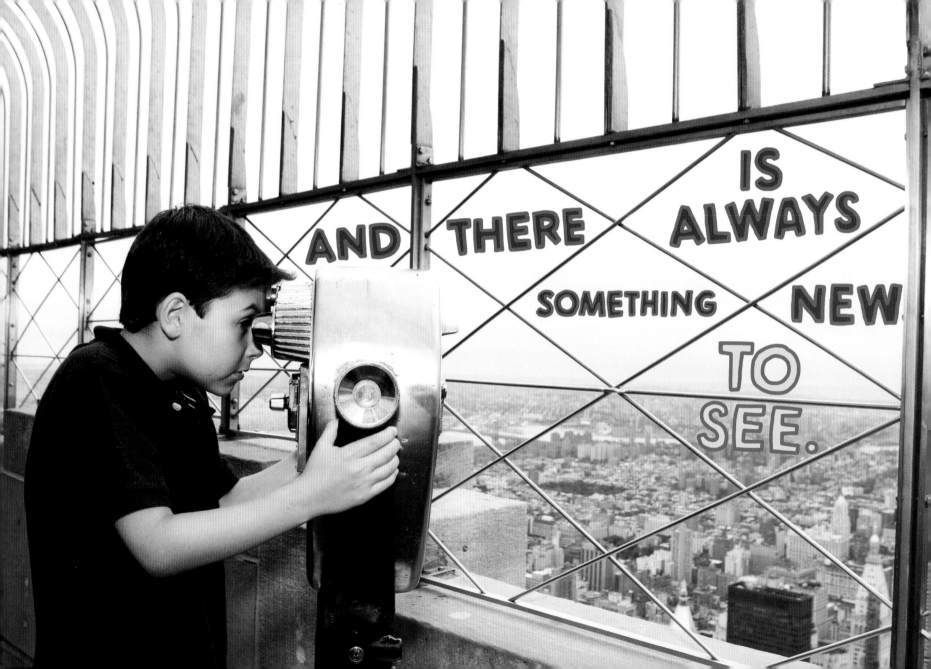

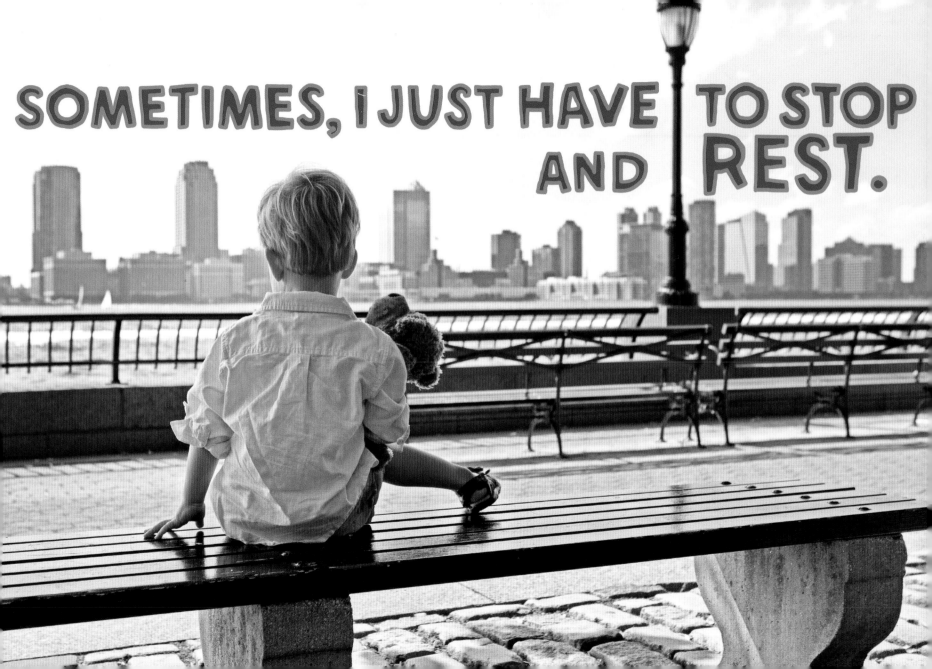

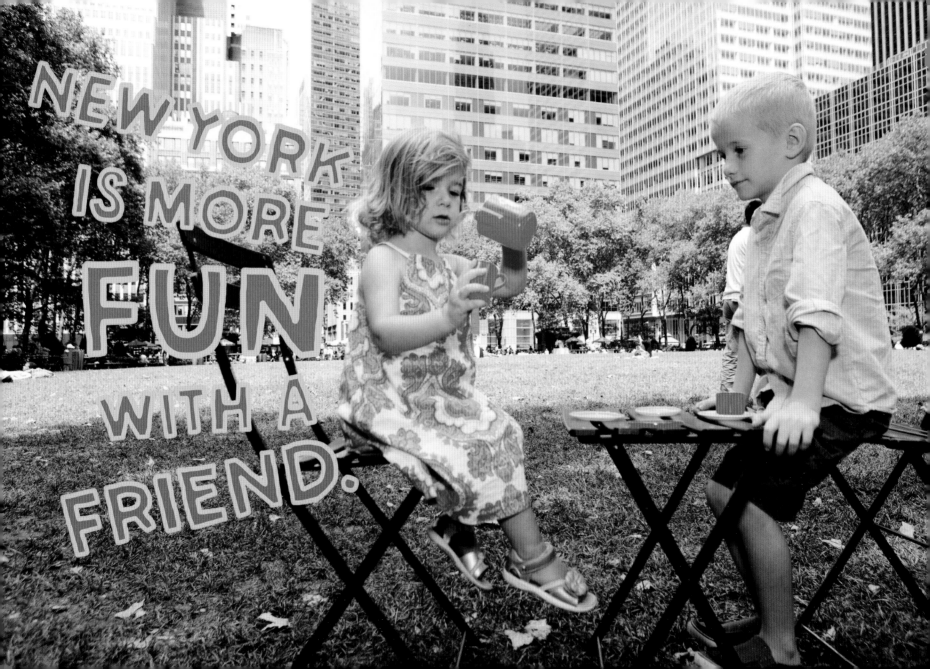

NEW YORK IS MORE **FUN** WITH A FRIEND.

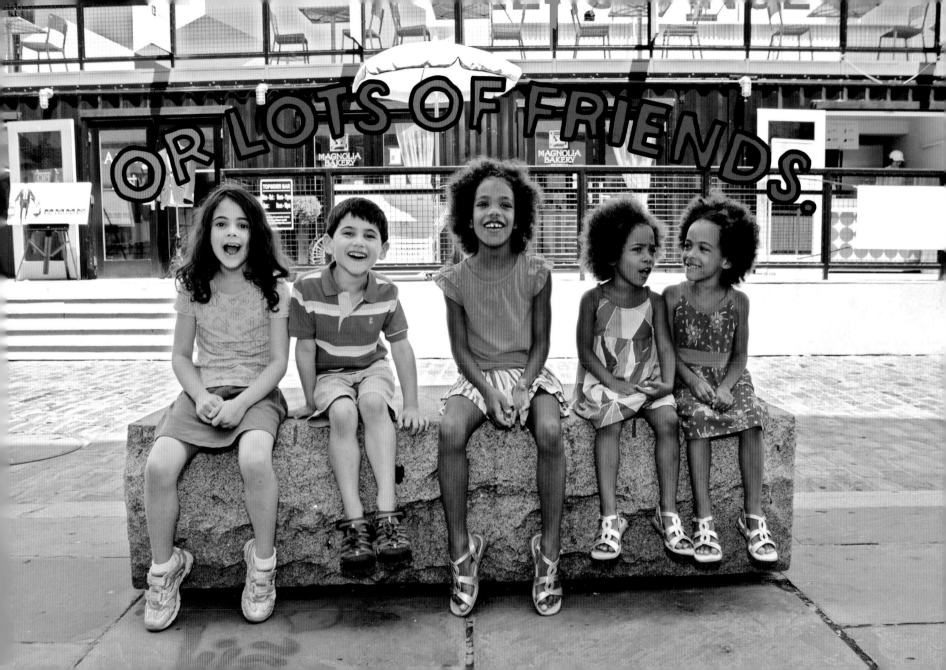

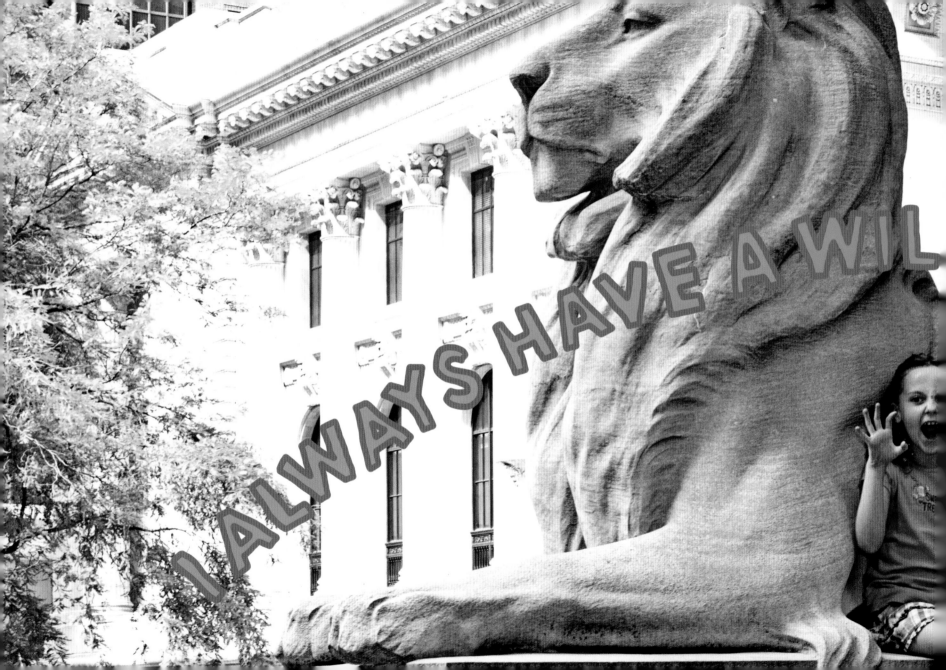

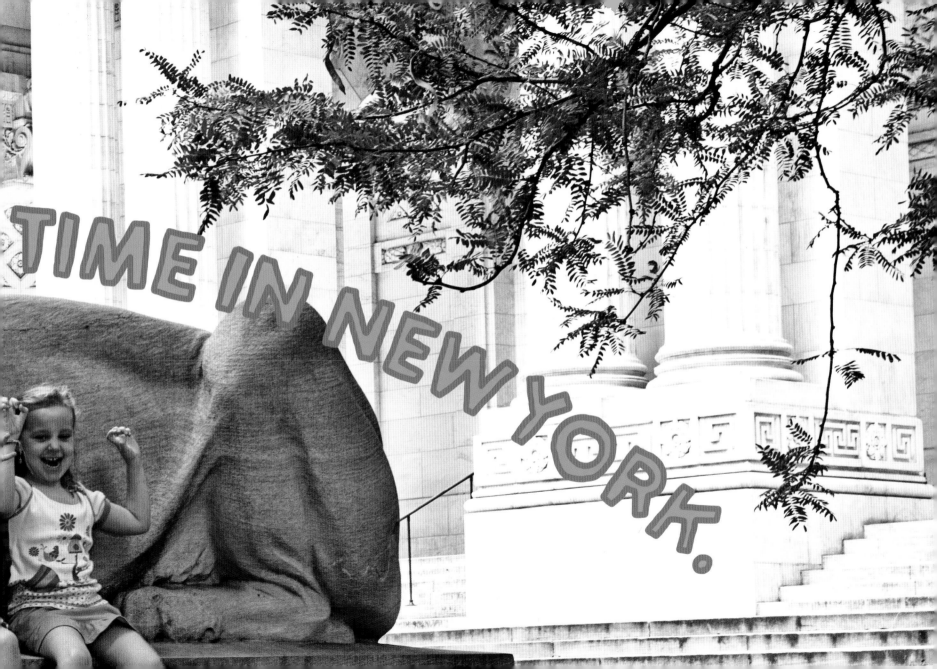

TIME IN NEW YORK.

New York is my Playground

Photographs © 2016 Jane Goodrich
Text © 2016 by Bob Raczka

All rights reserved. No part of this book may
be reproduced in any manner in any media, or
transmitted by any means whatsoever, electronic
or mechanical (including photocopy, film or
video recording, Internet posting, or any other
information storage and retrieval system), without
the prior written permission of the publisher.

Published in the United States by POW!
a division of powerHouse Packaging & Supply, Inc.
37 Main Street, Brooklyn, NY 11201-1021
telephone 718-801-8376
email info@POWkidsbooks.com

www.POWkidsbooks.com
www.powerHouseBooks.com
www.powerHousePackaging.com

Library of Congress Control Number: 2016930520

ISBN 978-1-57687-789-0

Book design by Krzysztof Poluchowicz

10 9 8 7 6 5 4 3 2 1

Printed in Malaysia